SHELBY LEE ADAMS
DEBBIE FLEMING CAFFERY
DOUG DUBOIS
ROLAND L FREEMAN
BIRNEY IMES
STEPHEN MARC
MARILYN NANCE

CLOSE TO HOME

Seven Documentary Photographers

Edited by David Featherstone
Untitled 48
The Friends of Photography
San Francisco

Untitled 48

This is the forty-eighth in a series of publications on serious photography
by The Friends of Photography. Some previous issues are still available.
For a list of these, write to Publication Sales, The Friends of Photography,
101 The Embarcadero, Suite 210, San Francisco, California 94105.

The Friends of Photography

The Friends of Photography, founded in 1967 in Carmel, California, is a not-for-
profit membership organization with headquarters in San Francisco. The pro-
grams of The Friends in publications, grants and awards to photographers,
exhibitions, workshops and lectures are guided by a commitment to photogra-
phy as a fine art and to the discussion of photographic ideas through critical
inquiry. The publications of The Friends, the primary benefit received by mem-
bers of the organization, emphasize contemporary photography yet are also
concerned with the criticism and history of the medium. They include the month-
ly newsletter *re:view,* the periodic journal *Untitled* and major photographic
monographs. Membership is open to everyone. To receive an informational
membership brochure, write to Membership Director, The Friends of Photog-
raphy, 101 The Embarcadero, Suite 210, San Francisco, California 94105.

ISSN 0163–7916; ISBN 0-933286–52–X
Library of Congress Catalogue No. 88–83257

Preface and Acknowledgements

The seven photographers whose work is presented in *Close to Home* photograph in strongly documentary styles, yet unlike many documentarians, they focus on the people and environment in the regions in which they were raised. The idea of photographing what one knows, of course, is not new. Eugene Atget's extensive oeuvre from Paris is the obvious example from the early days of the medium, and countless more recent photographers have used their home environments as a source of visual inspiration. Despite this, it is instructive to consider the role that travel has played in the development of the medium, particularly documentary photography. In the nineteenth century, European expeditionary photographers traveled through Africa and Asia bringing back pictures of colonial wonders, just as their American counterparts traced the course of their country's western expansion. In this century, documentary imagery has become motivated more by a concern for the livelihood and well-being of the people depicted. This tradition was fostered by Farm Security Administration photographers in the 1930s, war photographers and photojournalists in succeeding decades and globe-hopping younger artists today. In the process, a kind of aesthetic of distance has developed, one in which a geographic distance also establishes a psychological separation that allows the photographer heightened perspective of the subject. The notion of the objective record, of the neutrality of camera and photograph, is firmly attached to this kind of documentary, but the concept is no longer so easily or widely accepted. Contemporary photographers and audiences are aware of the biases and perceptions that are brought to documentary depiction, and this change is currently creating a shift in the way such images are viewed. How, it is thought, can an image removed from the mainstream of a culture, taken out of context and presented to an audience possibly even more ill-informed about the subject than the photographer, be seen as anything approaching "reality"? This book grew from a belief that successful documentary photography need not be contingent on artificially induced distance, and from an awareness that there were, in fact, a number of artists who were photographing in regions close to their childhood homes. The seven photographers included in *Close to Home* were selected after viewing the work of some thirty artists. Their work stood out not only because of its inherent strength, but also in the way that each complemented the others in the book through a diversity of style and content. These portfolios, each drawn from larger bodies of work, are informed by a kind of anthropological or ethnographic view of their subjects. The photographs range from a depiction of the physical characteristics of the population of an isolated community to investigations of specific aspects of cultural life in urban environments, from playful views of a single business enterprise to an intensely personal exploration of family. What is clear from these photographs, and particularly from the statements that accompany them, is that a deep understanding and knowledge of the subject of a documentary investigation can simultaneously be as revealing and alienating to photographers as a strange and distant land can be to a traveler. Even a photographer's intense involvement in a community does not overcome the intellectual sense of otherness that occurs when the camera intercedes. A book such as *Close to Home* only comes into being with the support of a number of people. I would first like to thank the seven artists included in the book for their patience, willingness and cooperation in meeting the various deadlines of the project, and particularly for the efforts they expended on their personal statements. Thanks too to those who suggested other individuals whose work we should review and to the photographers who were considered but whose imagery was not ultimately selected. A special thanks goes to Jason Rowe, who volunteered his services as editorial assistant and took an active role in all aspects of the book's preparation. Thanks also go to Michael Mabry and his staff at Michael Mabry Design for their intelligent design of the book. David Featherstone, Editor, The *Untitled* series

The Photographers

Shelby Lee Adams

Born in Eastern Kentucky in 1950, Shelby Lee Adams received a M.A. degree from the University of Iowa in 1975 and is to receive a M.F.A. degree from the Masachusetts College of Art in 1989. Adams is currently head photography instructor at Salem State College in Salem, Massachusetts. During the summers, when he is not teaching, he returns to Appalachia, where he continues to photograph the people in the isolated communities near where he was raised. In this project, begun more than ten years ago, Adams has focused on a community of poor and disenfranchised families and on a group of religious fundamentalists who are part of the Holiness Serpent Handlers. Most recently, he has begun a series of portraits of men who have committed violent crimes.

Debbie Fleming Caffery

Born in 1948 in New Iberia, Louisiana, Debbie Fleming Caffery studied photography at the San Francisco Art Institute, receiving her B.F.A. degree in 1975. Since then, she has been living and photographing in the small, rural community of Franklin, Louisiana. She was the recipient of photography fellowships from the Louisiana State Arts Council in 1983 and the Southern Arts Federation in 1987. Caffery has photographed consistently in her immediate community, continuing work on several long-term projects. In one begun four years ago, she has photographed a field worker named Polly, creating an extended portrait with images of Polly's hands, the interior of her room and personal items as well as traditional portraits. This same energy and imagination appears in her theatrical portraits of her children and in the images of field workers during the sugar cane harvest.

Doug DuBois

Born in 1960 and raised in Somerset County, New Jersey, Doug DuBois received a B.A. degree from Hampshire College in Amherst, Massachusetts, in 1983. He then moved to San Francisco to continue his studies in photography at the San Francisco Art Institute, where he received his M.F.A. degree in 1988. He received the Murphy Fine Arts Fellowship from the San Francisco Foundation in 1987. DuBois currently lives in San Francisco, where he works as a color printer, and is continuing his series of photographs about his family in New Jersey. This body of work was exhibited at San Francisco Camerawork Gallery in 1988.

Roland L. Freeman

Roland L. Freeman was born and raised in Baltimore, Maryland. Primarily self-taught as a photographer, his interest in the medium grew out of his involvment with the civil rights movement. In the early 1960s he began photographing marches and demonstrations, and by 1967 he was working full time as a photojournalist. In 1971 Freeman began stringing for Magnum Photos and doing assignments for American and European periodicals. He coordinated a 1972 presentation about Baltimore's Arabbers as part of the Smithsonian Institution's Festival of American Folklife, and he has since been a field research photographer for this festival. Freeman has received support from the National Endowment for the Humanities, the National Endowment for the Arts and the Maryland Arts Council for his Arabbers project. A book of this work is to be published by Cornell Maritime Press, Inc./ Tidewater Publishers in the fall of 1989. Freeman currently lives in Washington, D.C.

Birney Imes

Born in 1951 and raised in Columbus, Mississippi, Birney Imes is essentially self-taught as a photographer. In 1973 he received a B.A. degree in history from the University of Tennessee. After a period of travel, he returned to his native Mississippi where, with the influence of a friend, he took up photography. Imes was awarded individual artist's fellowships from the National Endowment for the Arts in 1984 and 1988; he received the photography award from the Mississippi Institute of Arts and Letters in 1987. Imes has been photographing in the area surrounding his Columbus home since 1974. He is currently completing work on a series of photographs of juke joints in the Mississippi delta, a book of which is to be published in 1991.

Stephen Marc

Stephen Marc was born in 1954 and was raised in Champaign-Urbana, Illinois, and Chicago's Southside. He received a B.A. degree from Pomona College in Claremont, California, in 1976 and continued his studies in photography at the Tyler School of Art of Temple University in Philadelphia, where he received a M.F.A. degree in 1978. Marc was the recipient of an Artist's Fellowship from the Illinois Arts Council in 1987. In 1983, with the support of the Eli Weingart Chicago Grant awarded to him through The Friends of Photography, Marc self-published a book of his photographs entitled *Urban Notions.* He currently lives in Chicago, where he teaches photography at Columbia College. Marc is presently one of a group of photographers involved in the "Changing Chicago" documentary project sponsored by the Focus Infinity Fund.

Marilyn Nance

Marilyn Nance was born in 1953 and grew up in Brooklyn, New York. She studied journalism at New York University and Communications Graphic Design at Pratt Institute, where she received a B.F.A. degree in 1976. Nance won the Award of Excellence for Communications Excellence to Black Audiences sponsored by The World Institute of Black Communications in both 1985 and 1986. She received a New York State Council of the Arts Grant in 1987 for her work on the project presented here. Nance currently lives in Brooklyn, where she works as a freelance photojournalist and is continuing work on *Religion: Spiritual and Religious Expressions of African Americans.*

ROLAND L FREEMAN

The Arabbers Photodocumentary Project

"Arabbing" is a folk term peculiar to Baltimore that refers to the selling of goods from horse-drawn wagons, pushcarts, trucks and corner stands by hawkers or street vendors. Derived from "arab" or "street arab," colloquial words for a peddler, the term is most often applied to the selling of produce from horse-drawn wagons. Some of the clearest memories I have from my early childhood in Baltimore are of my father selling produce on a horse-and-wagon and of the hollers he used to advertise what he was selling. My father, like the others who did this, was known as an "Arabber." Like many of the kids in my neighborhood in 1939 and 1940, I was fascinated by these men and wanted to be one. I was not aware at the time that there was an Arabbing tradition in my family dating back to before the turn of the century to my great-grandfather. I entered the profession when I was eight or nine and worked for my Great Uncle Handy, who owned a big stable and had a produce business that employed about thirty or forty men year-round. For many kids, Arabbing was a part-time job, much like delivering newspapers or working at a fast food restaurant is today, but it was different for me. I really loved being on those wagons, traveling all over the city and meeting different people. I would probably still be an Arabber today if my very wise mother, in 1948, had not gotten me off what she considered the "mean streets" of Baltimore and sent me to live on a farm at the age of twelve. However, much of what I know today, and much of what I live by, I learned on the wagons. Some twenty years later, while visiting my grandmother in Baltimore, I ran into a childhood friend who was still Arabbing. Our meeting rekindled my love for this tradition, and I instantly knew that I wanted to document the Arabbers' way of life. It was not as easy to do this as one might think. A lot of water had gone under the bridge since I left Baltimore; in fact, I had circled the globe. In the intervening years, I had distanced myself from these early experiences geographically as well as psychologically and professionally—but not emotionally. Re-entering this world with a camera made my outsiderness more explicit, but photographing eventually helped people trust me more and established some common links. When the Arabbers saw the results of my documentation and recognized that my photographs were serious and honest, they opened up more and things became easier. On the other hand, being an insider was also painful, and I have come to understand why there are relatively few photographers who have turned their cameras on their own kind. Since I felt no emotional distance from my subject matter, I was in the difficult position of feeling something very deeply while at the same time trying to express those feelings photographically. Because I had once lived these scenes, taking the pictures was a special event. My previous Arabbing experience gave me an intuitive sense of what to focus on. Even with this understanding, however, it still took awhile to resolve the problem of how to be part of what was happening and simultaneously to transform into photographs the essence of the Arabbers' way of life accurately, respectfully and appreciatively. There is very little I have done photographically in the last twenty-five years that has meant more to me than bringing this project to fruition.

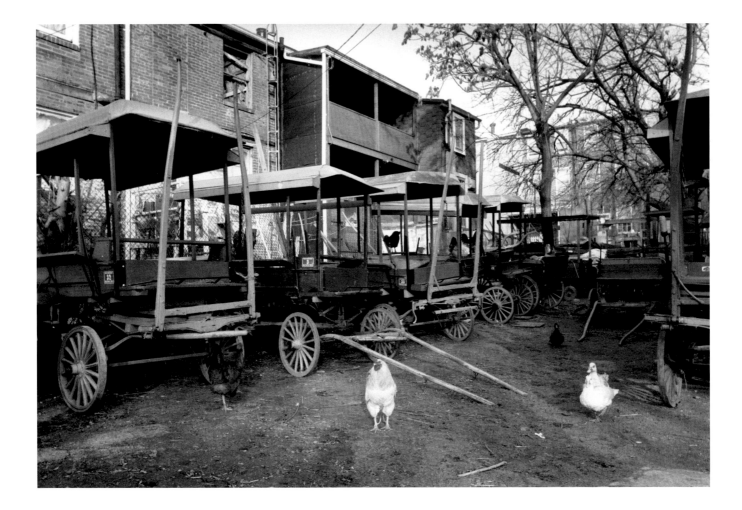

"Buddy" Kratz' stable yard. Baltimore, Maryland, Fall 1986.

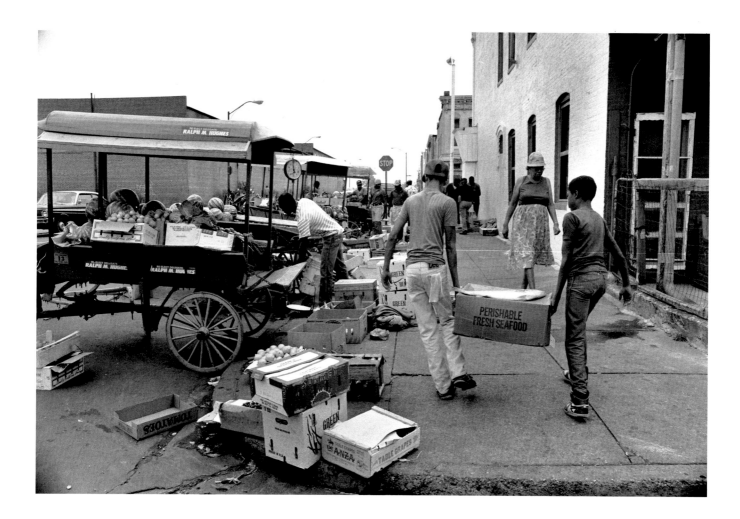

Loading and decorating wagons on Winchester Street near the Allen family stable.
Baltimore, Maryland, Summer 1987.

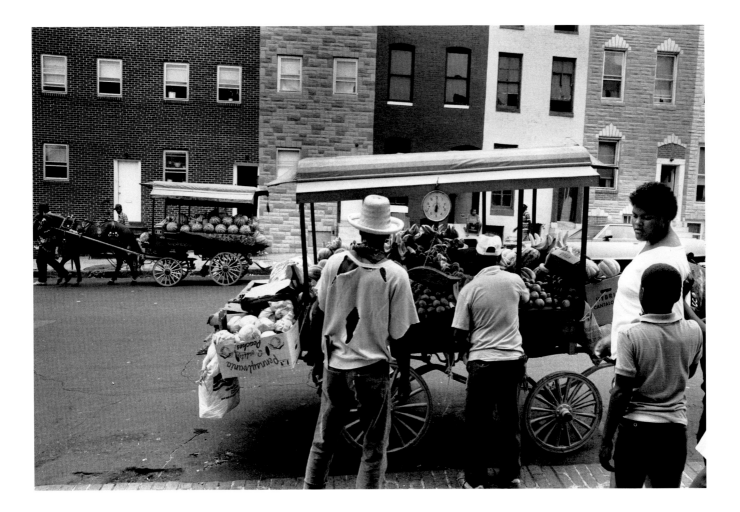

Loading and decorating wagons on Winchester Street near the Allen family stable.

Baltimore, Maryland, Summer 1987.

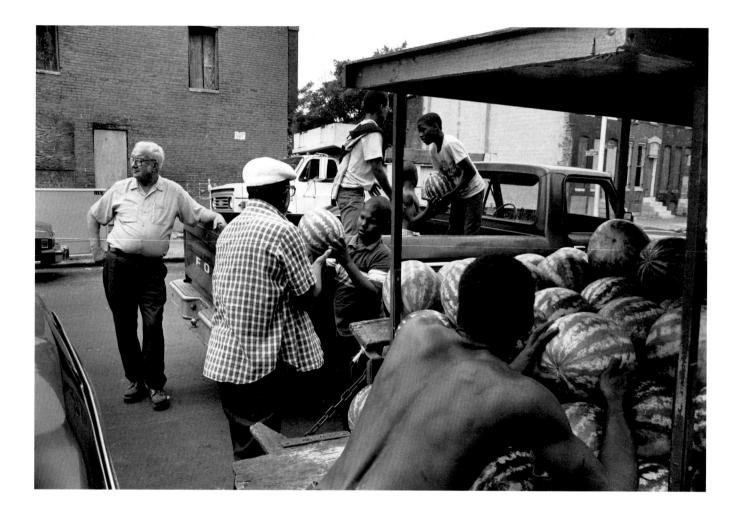

Arabbers loading watermelons near the Allen family stable.
Baltimore, Maryland, Summer 1987.

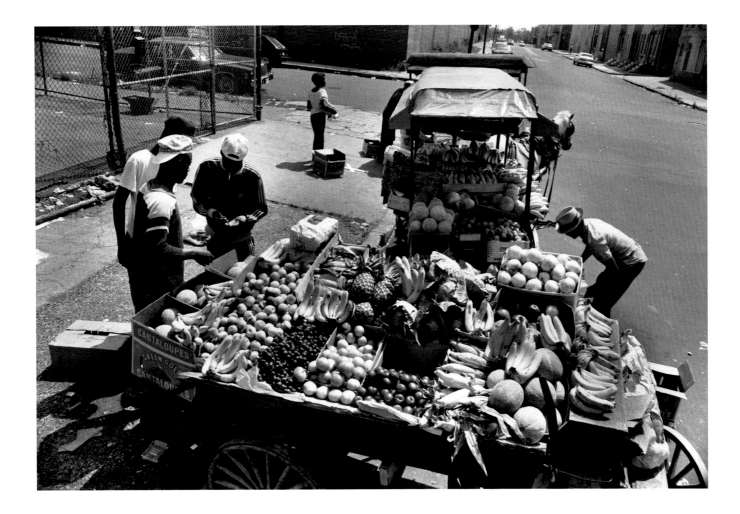

"Gummy" and Morris "Popeye" Levi on their route. West Baltimore, Maryland,
Summer 1986.

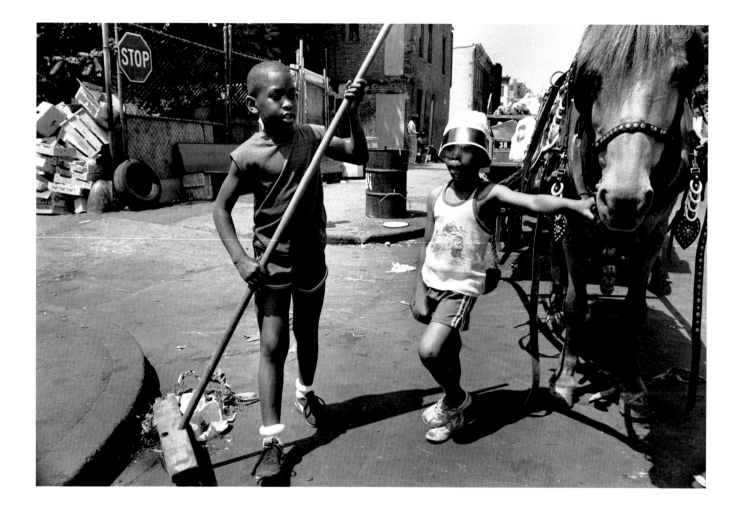

Young Arabbers cleaning the street outside the Allen family stable.
Baltimore, Maryland, Summer 1986.

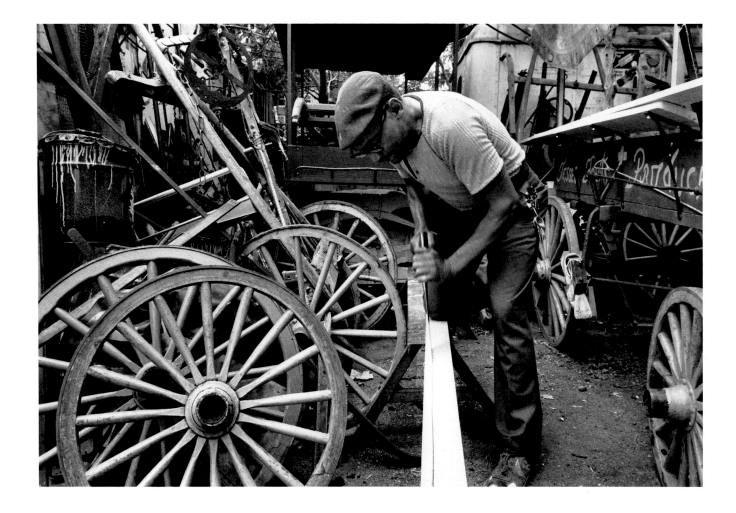

Walter "Teeth" Kelly mending wagons at Walter "Buddy" Kratz' stable.
Baltimore, Maryland, Summer 1986.

DEBBIE FLEMING CAFFERY

Sugar Cane Harvesting

In my diary I often write about scurrying mice in fields or along country roads near my home in rural Louisiana. I sometimes feel that I see my photographs out of the corners of my eyes. Like those mice that whisk in and out of a hole then vault into the safety of a corner, the things that make up my images seek the security of a square frame. There are many ingredients important to my photographs—the ones finally cornered—and through the years I have developed an understanding of how these elements interact. Among these are establishing friendly relationships and rapport with my subjects, working consistently in one area and becoming involved in the activities of the community. Returning to Franklin to photograph has allowed me to work in this concentrated way. I've become more focused within my whole environment, concentrating on the isolated beauty I find here. While my first images were more directly documentary, as the years have passed my work has taken on a more personal, subjective emphasis. During one of my first photography classes, I found myself in the fields working on an assignment, and I immediately became enthralled with the whole process of sugar making. I discovered that the weather played a huge role in the life of a farmer, and it has become equally important to me. My understanding of light came at about the same time as my understanding of the weather. Heat, rain, fog, humidity, sometimes cold—and the time of day for the perfect light—have become obsessions. When I make an image such as *Sunrise—Fire,* I become completely involved with the atmosphere around me, the feeling of the mist, the noises, the smells from the mill. In the photograph of Pa Pa, the movement of the smoke around him and the way his whole body seems to flow from his hat to the fire reflects the gracefulness of the sugar making process. The photograph of the man in the tractor was made at sunset, as the day was ending. I was exhausted and my face was windburned. The tractor was dirty, and as the driver waited in line to bring it into the shed, the ceremony of the day's events faded. The objective facts surrounding my pictures, combined with my perceptions and feelings about those realities, result in photographs that work for me. When I look at them I see how I feel about my environment, particularly the harvesting. Even though there is an abstract aspect to the more recent images, the photographs derive a great deal of power from the organic intensity of the harvest. I feel the excitement and urgency of the rush to harvest the cane before the crop is damaged by winter freezes. Although the later images still document factual events, they have become more concerned with how I feel about the activities. In the last few years, my photographs have become darkened and veiled. Perhaps these images are also coming from a part of my soul. They are a little lonely and melancholy, but completely alive. When I was a child, I used to think my soul was floating around invisibly from the base of my neck to under my ear. Now it seems to be an invisible line from my eyes to my heart to the tips of my fingers—expressed as an image. There is something solitary in my work even though most of it is about people; working with my camera allows me to be alone yet also in the midst of much activity; the decisive moment is a singular moment.

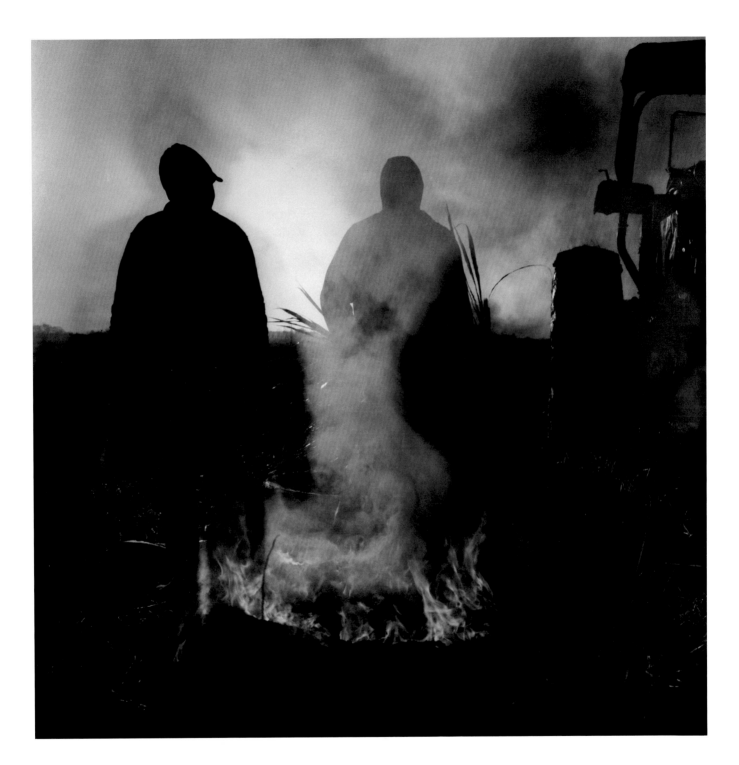

Sunrise—Fire, December 1984

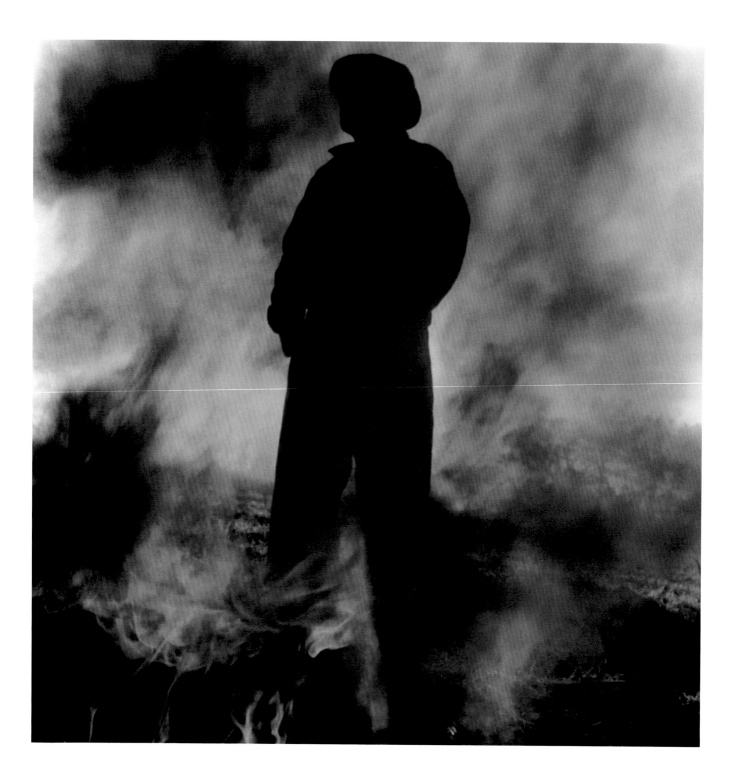

Untitled, 1986

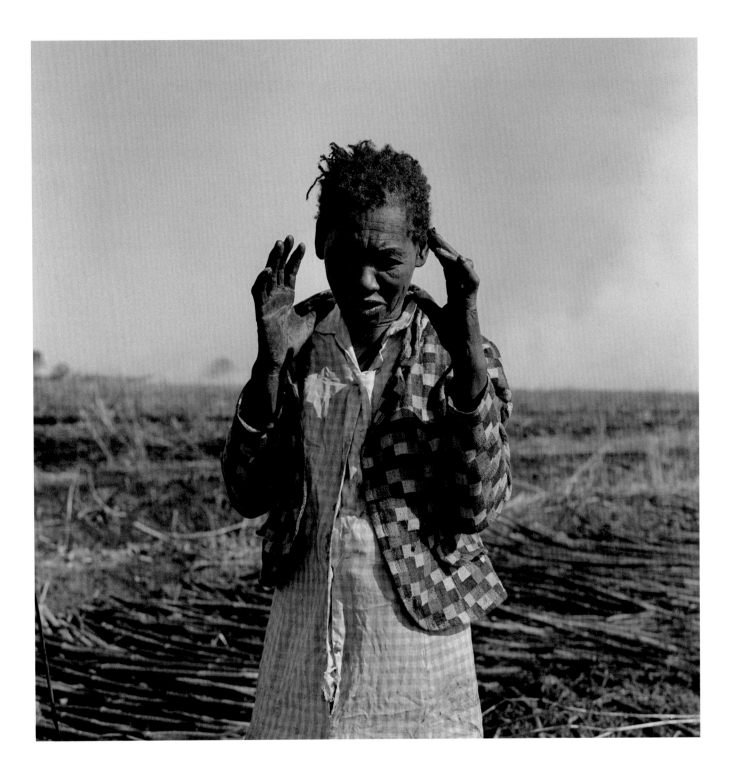

Praying, 1986

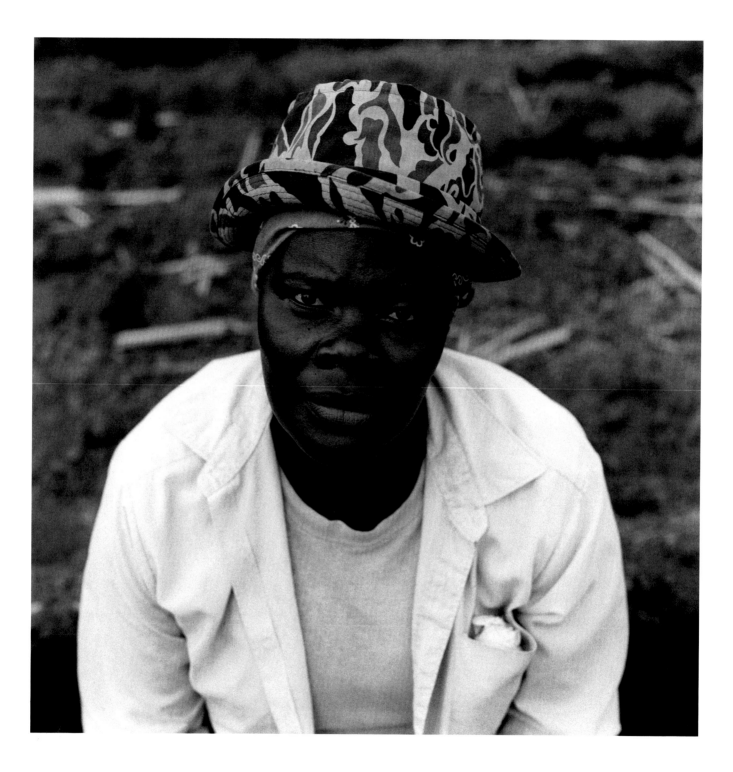

Untitled, October 1983

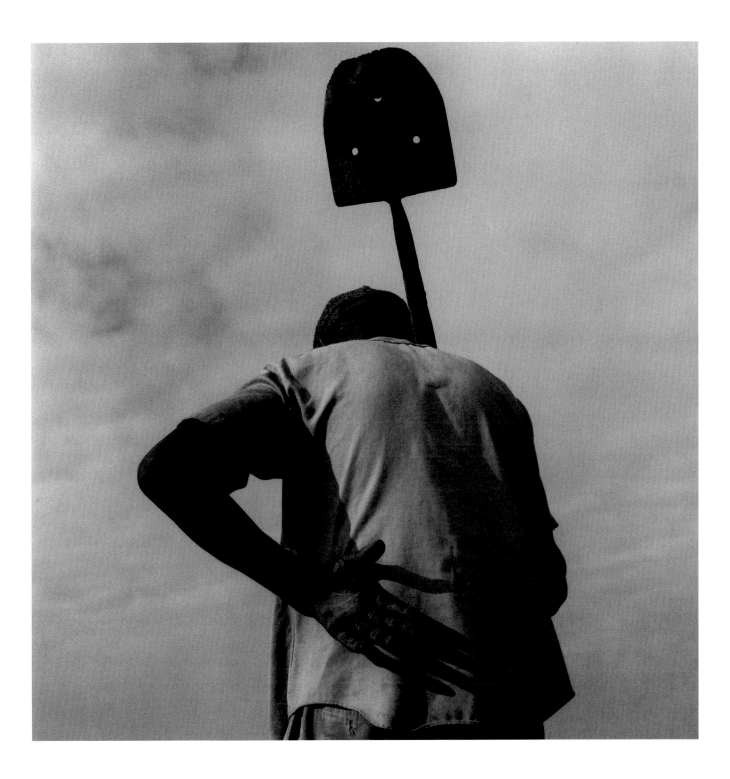

Pa Pa, December 1987

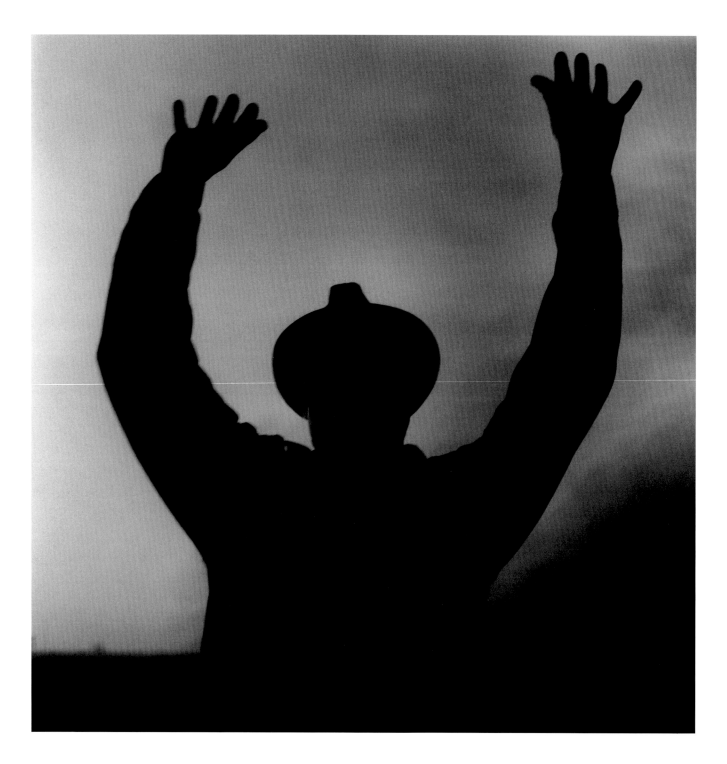

Pa Pa, December 1987

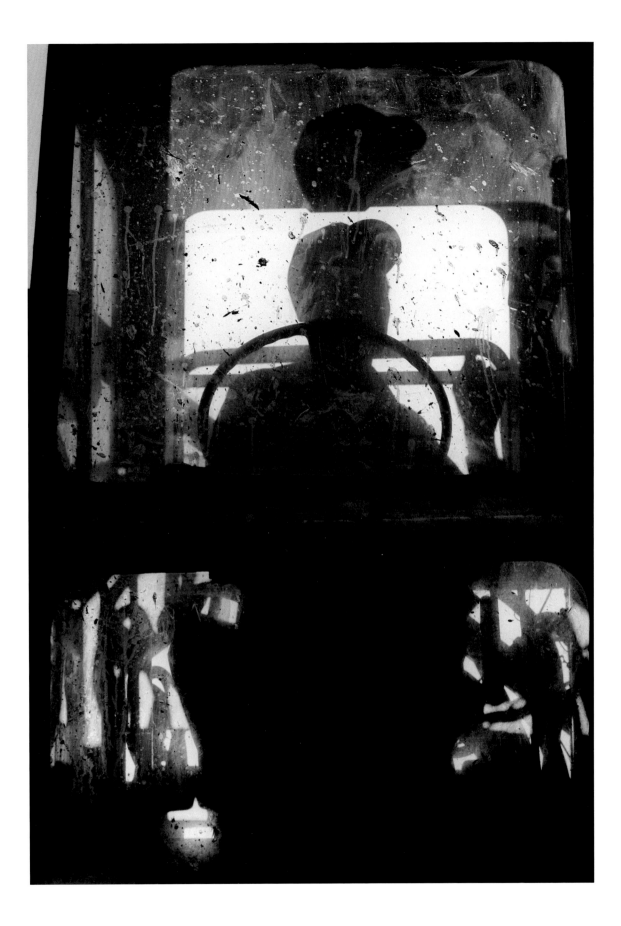

Sunset—Tractor, Harvesting, 1986

STEPHEN MARC

Street Photography

These photographs are from two places that are very important to me. The first, Chicago, is where I grew up and where I now live. The other place, Champaign-Urbana, Illinois, about 140 miles away, is my home away from home. I have spent so much time there that friends sometimes forget I moved to Chicago at age three. In Chicago, I concentrate on the southside Afro-American community; in Champaign-Urbana, my activity centers around the predominately Black "North End" and the University's campus town. I have been working on this project for over a decade. I am a street photographer interested in making a visual statement about the collective Black community, and the best place to start is at home. What I wish to portray is a sense of the atmosphere in the neighborhood through a visual exploration of the various social interactions, celebrations and events that are part of everyday life. My work is a personalized record that is neither propaganda nor an airing of dirty laundry, but rather an attempt to show that, in spite of many "urban problems," there is a strong sense of identity and comradery, and even of extended family. The Black community is large and diverse. Its characteristics are often universal, but they can also be beautifully unique. Although I photograph a variety of community events, urban landscapes and other environmental details in my work, I am especially attracted to the younger set—kids, teens and young adults. What attracts me is their high energy, their creative expression and the sense of ritual involved in the process of their socialization. As a documentary photographer, it is important to blend ethics, aesthetics and information. The viewer should also feel a sense of involvement. I do not believe that documentary photographs must necessarily address social ills or be limited to specific social classes, although there have certainly been many such images that have made important contributions to very worthy causes. Each photographer serves a different role in producing a comprehensive record of class and culture. What concerns me are photographers who seek a particular situation or environment because it has a certain "look," without trying to understand or interact with that culture. The photographer, in accepting responsibility as a documentarian, must show respect, sensitivity and an open-mindedness concerning the subject. A documentarian, as either an insider or an outsider, should attempt to produce a message worthy of the trust, participation and tolerance of the people around and in front of the camera. Photographers should constantly question and re-evaluate the effectiveness of their work. They must bring to it a positive sense of values, but it is not necessary for the photographer to be an insider for the statement to be valid. The beauty of being an insider is that you don't have to explain why you are there, only why you brought the camera. As an insider, I feel I am granted certain in-house privileges, and I am more frequently able to photograph without disturbing the flow of activity.

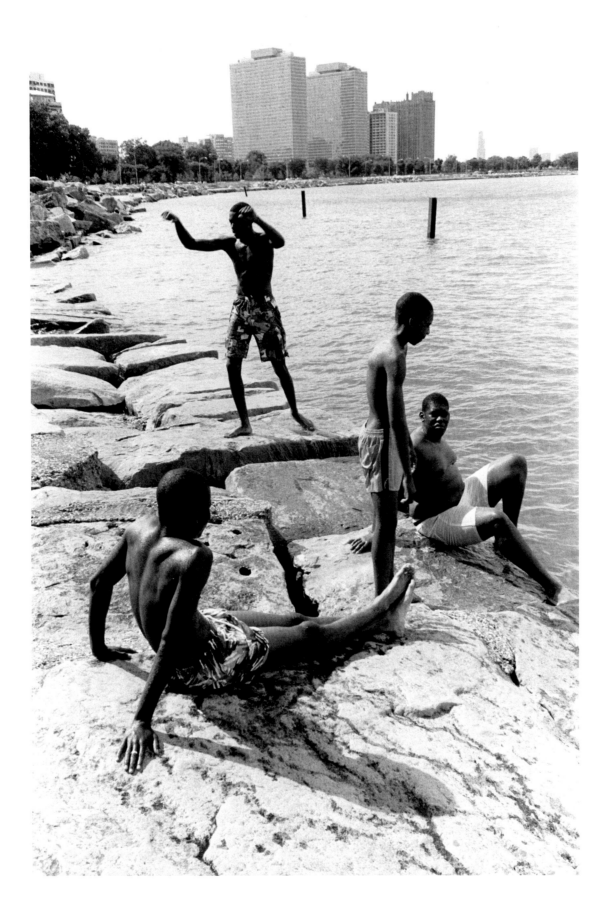

A group of teenagers diving off the rocks into Lake Michigan,
each man trying to outdo the last either in terms of style or comic appeal; 1987.
From the <u>Changing Chicago</u> project.

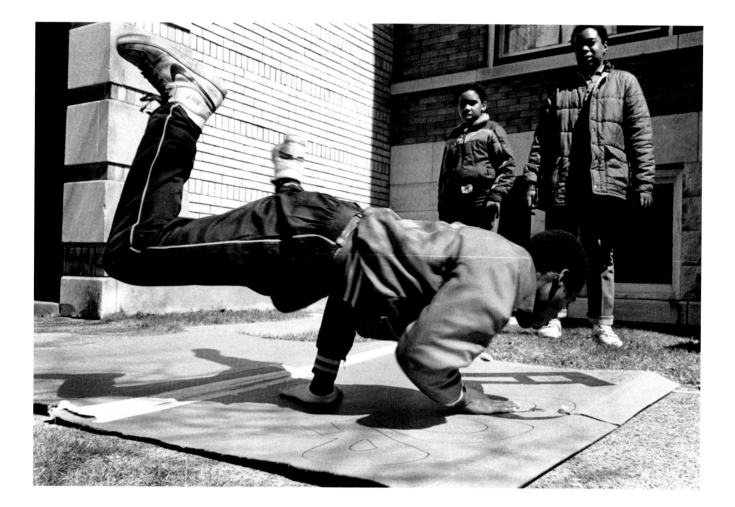

A break dancer who often performed in the downtown
area perfecting the "helicopter" before the next street show; 1984.

While the two boys were fighting, to add insult to injury, the one in control talked
the whole time. At the moment of the photograph he taunted, "You know I'm bad 'cause I'm number one."
The fight was already going on when I first saw them, and it continued as I left; 1983.

Off duty, this dog was a playful puppy, but upon command the scene
completely changed. The dog was so well trained I could almost believe he put on his own t-shirt; 1987.
From the Changing Chicago project.

With music blasting from a second floor window,
this dance troupe stole the show at their annual block club party talent contest; 1988.
From the Changing Chicago project.

A member of Omega Psi Phi Fraternity proudly displaying his brands.
Members of several fraternities brand themselves, and the men of Omega Psi Phi exhibit a great deal of skill
and artistry in this voluntary ritual. To me, it appears to be a modern Afro-American
cross between the branding of slaves and livestock and the beauty of African scarification; 1986.

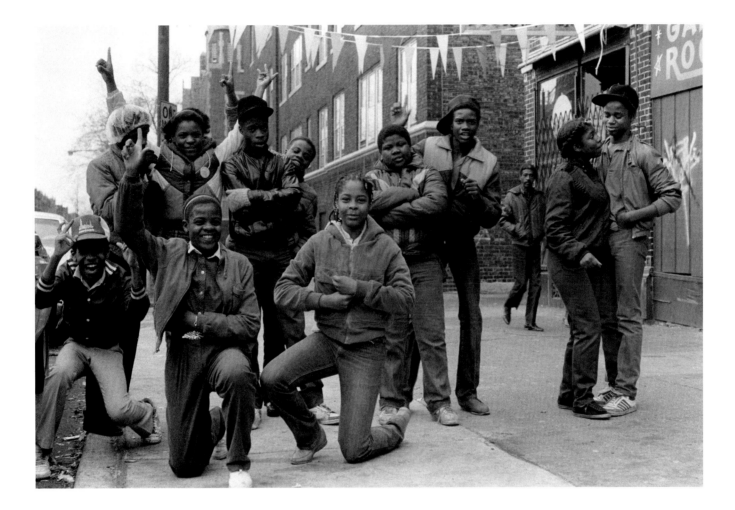

A neighborhood group posing in front of a game room
flashing a variety of gang signs and individual gestures for the camera; 1983.

BIRNEY IMES

The Whispering Pines

For almost fourteen years I have been photographing in two rural counties near my home in Columbus, Mississippi. Rather than approach this work in a systematic or methodical way, I often rely on whim or instinct in deciding where I go, and I strive to make the process leisurely and enjoyable. I ride out through the country with hopes of finding a site or a situation that will yield photographs, but there are certain people and places that serve as touchstones for me as I travel about. One of the places that I have been visiting over the years is called The Whispering Pines. The Pines is the shell of a restaurant and bar built by Blume Triplett for his wife Eppie in 1949. In its day, the Pines had a flourishing restaurant trade. One could eat a steak in the Yellow Canary Dining Room, then go outside and dance to jukebox music under a blue neon moon that hung in the swaying pine trees that surrounded the concrete dance floor. After Eppie's death in 1973, the Pines stopped serving food, and business slowly declined. The restaurant is now run by Rosie Steverson, a fifty-two-year-old woman who has worked there for more than twenty-five years. The Pines was built with separate sides for its black and its white customers. Today, the white side is clogged with an assortment of debris that Blume has amassed over the years, and what business there is takes place on the black side. Some things that I have found—and sometimes photographed—while wandering through The Pines are dried chicken feet tied to a quart beer bottle on top of a "Hello Dolly" pinball machine, piles of old political campaign posters behind stacks of old cigar boxes each bearing the date of when it was first opened and a dozen or so old jukeboxes, one with the song "Whistling Pines" by Big Joe Williams, a bluesman who lived in nearby Crawford. These physical attributes, coupled with my interest in the interaction between Blume, a white Mississippian lacking two years of being as old as the century, and his mostly black clientele, and later my deepening friendship with Blume and Rosie, have sustained my interest in The Whispering Pines as an ongoing photographic project for me. Most often my visits are random and unannounced, but sometimes I go there with some specific photographic idea in mind. This is usually when some scheduled event is taking place: the shooting of guns into the air at midnight on New Year's Eve, a birthday party for Blume, or a chitlin supper given for the regulars. One recent night I went out to The Pines for a visit, keeping a promise I had made to Blume over a month before to bring him a chocolate meringue pie from Buck and Helen's. Before Blume had finished his first piece of pie, John came in with a plastic jug of moonshine and offered Blume a drink. Later T.P., Rosie's brother, came in and for the rest of the evening we talked, told stories and laughed. In the more than ten years that I have been photographing in and around the Pines, I have used a variety of cameras and approaches. I have photographed the place and its contents with a large-format view camera, made portraits with a tripod-mounted rollfilm camera and photographed activities going on there with a handheld camera with flash. As one of the regulars at the Pines, I spend more time visiting and talking with the people than I do photographing. When I do get out my camera, it is part of the natural ebb and flow of events, and little changes unless we are taking posed pictures. Photography is as routine an activity as playing the jukebox or drinking a beer at the counter. The Pines has been a rich source of pictures for me. Though my primary concern has been the singular image, in the process I have generated a group of pictures that I hope will preserve the look and spirit of the place and the people who pass through it.

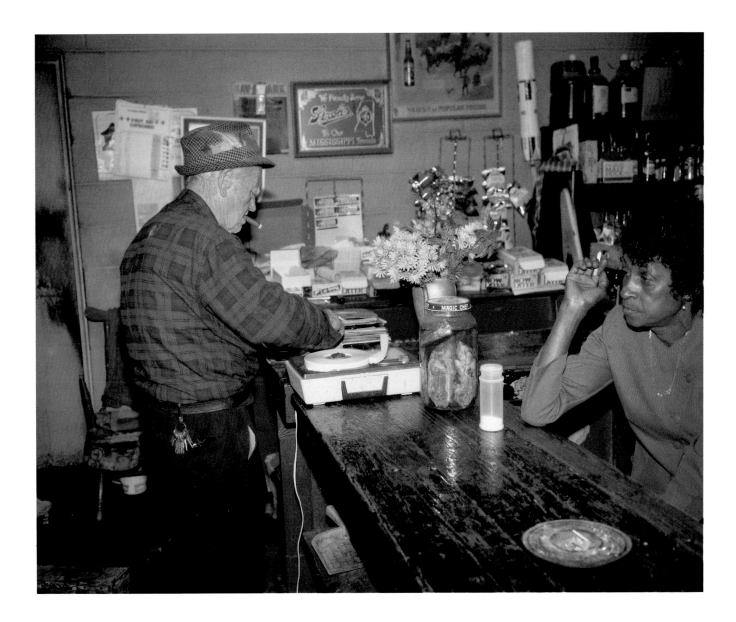

Blume and Mary Will Thomas, New Year's Eve, 1984

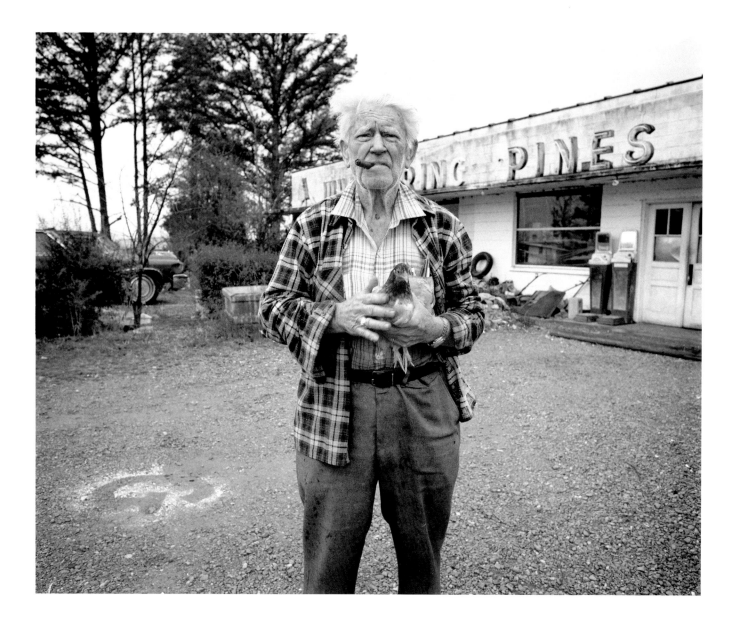

Mr. Blume in Front of The Pines, January 18, 1986

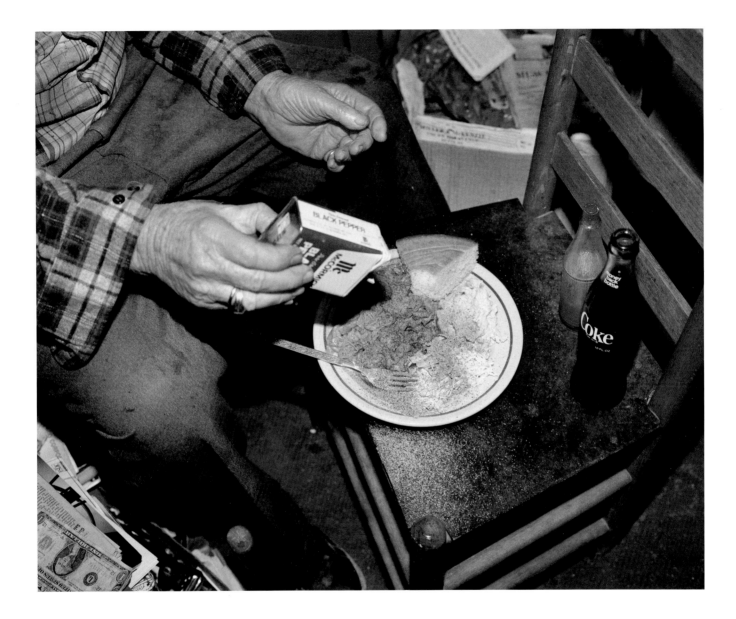

Blume with Plate of Chitlins, January 18, 1986

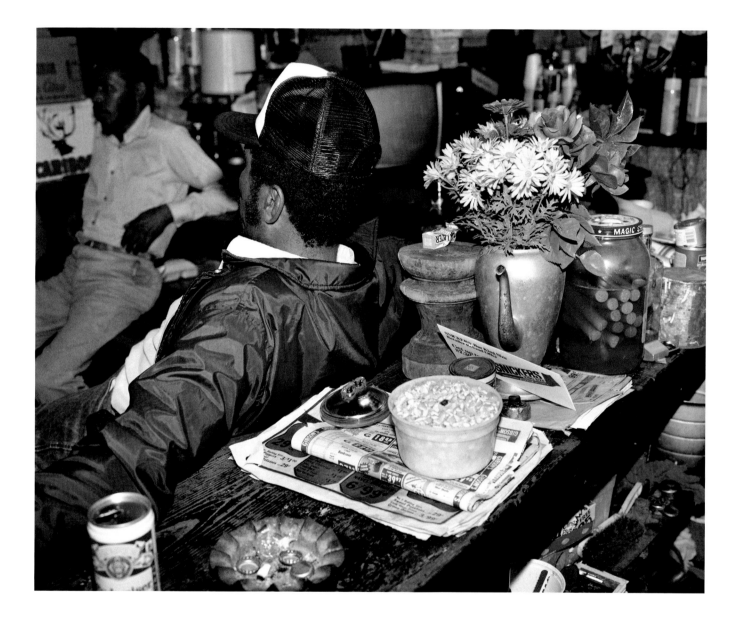

Bartop with Leo and T.P., January 18, 1986

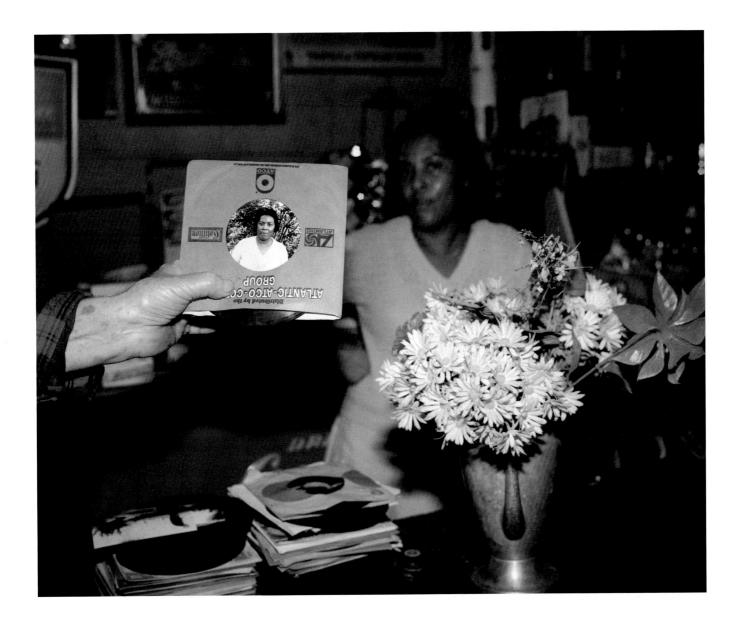

Record with Rosie's Picture, New Year's Eve, 1984

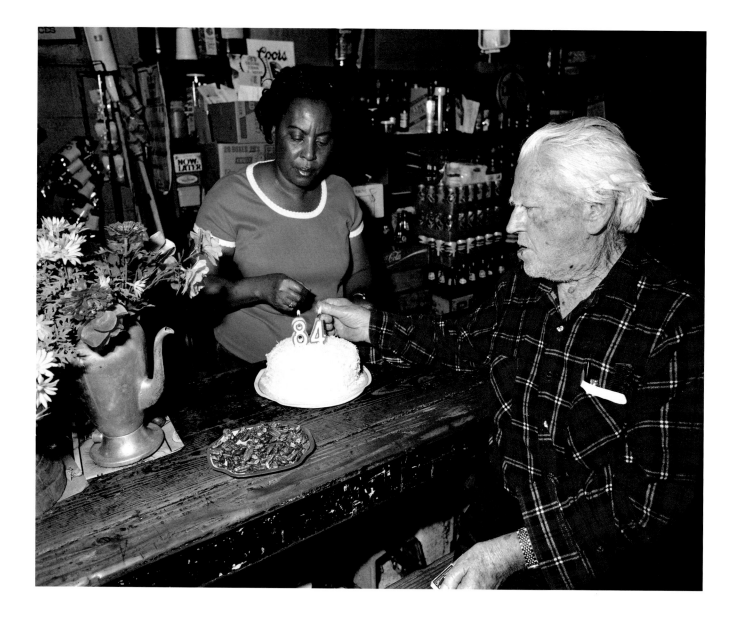

Blume and Rosie with Birthday Cake, April 19, 1986

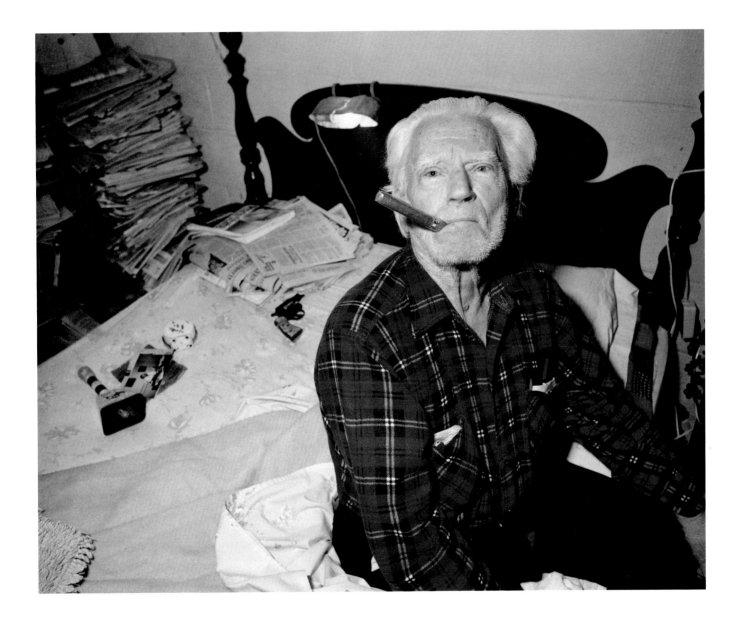

Mr. Blume on his 84th Birthday, April 19, 1986

MARILYN NANCE

Religion: Spiritual and Religious Expressions of African Americans

I have always been interested in spiritual matters. A lot of people in my family died while I was a child, and I frequently wondered what happened to them. I grew up in the Farragut projects in Brooklyn, and the kids in our building would go to St. Ann's Catholic Church together. On Sunday we would lay handkerchiefs on our heads, dash some holy water on, make a cross, sit down, kneel down and sit again until church was all over. The services were in Latin. I thought, "If only we were Puerto Rican, we'd know what was going on." Sometimes we would go to the Church of the Open Door, but that was boring. Sometimes my mother would go to church by herself, and my sister and I would critique her as she stepped out in her 1940s suit and hat. I don't remember why, but my sister and I started going all the way to Harlem to the Baptist church that my mother joined when she first came to New York City. My Uncle Emery was a deacon there, and Aunt Lucy was a deaconess. We took the A train up there every Sunday, even the day after the riots of 1964. I liked the Baptist church, especially the music. We would sit up in church and predict who was going to get happy. I got baptized there when I was about ten or eleven. I don't remember when I stopped going to church, but I do remember the first Black Power rally I went to. It was in 1968. I stopped straightening my hair after that. The call then was for us to redefine ourselves. There was plenty of work to be done, and while religion seems always to have been a component in our movements—witness Harriet Tubman, Nat Turner, Marcus Garvey, Malcolm X, Martin Luther King and Jesse Jackson—I did not realize until recently the spiritual work that had to be done. Now that I'm getting older, I'm becoming more and more aware of how religious activities fulfill that need for power, fellowship and healing. In order to do all the other work we have to do, we have to have faith and positive mental attitudes about ourselves and our lives. In the quest, many of us are actively reclaiming our African religious and healing traditions and forming strong spiritual connections. 1986 was the year of the First Annual Community Baptism for the Afrikan Family, which was described on the flyer announcing it as "a spiritual/cultural ritual whose purpose is to continue the ancient and sacred tradition of our ancestors of cleansing and purification of the soul and rededication of our lives to the Almighty Creator. The objectives: Unification of the Family, Reawakening of our Innervision, and the Strengthening of Our Spirit." I figured I could use all of that, but my photojournalist heart said, "Girl, you ought to shoot it." So I did. I got permission first. On the day of the summer solstice, my husband, son and I, dressed all in white, assembled at midnight at a Brooklyn church for prayer and meditation accompanied by African drums and a gospel choir. Lots of our friends and my son's buddies were there. It felt very special. Just before dawn, we traveled to Riis Beach, some ten miles east of Brooklyn, for the baptism. After photographing just about everyone else getting submerged, I handed my camera to a friend and asked her to photograph my family and me getting baptized. Well, I didn't exactly come up shoutin', but 1986 was the first year that I ever got a grant. These photographs are from a body of work still in progress. All of the pictures shown here were taken in and around New York City. They may look like I went to exotic places, but I didn't. In working on this project, I have traveled to backyards, local beaches and resorts, street corners and stadiums, churches and community centers. In these pictures are people who live around the corner from me, people I grew up with, people I went to school with. Someone once asked me, "Where do you find those people?" Those people?

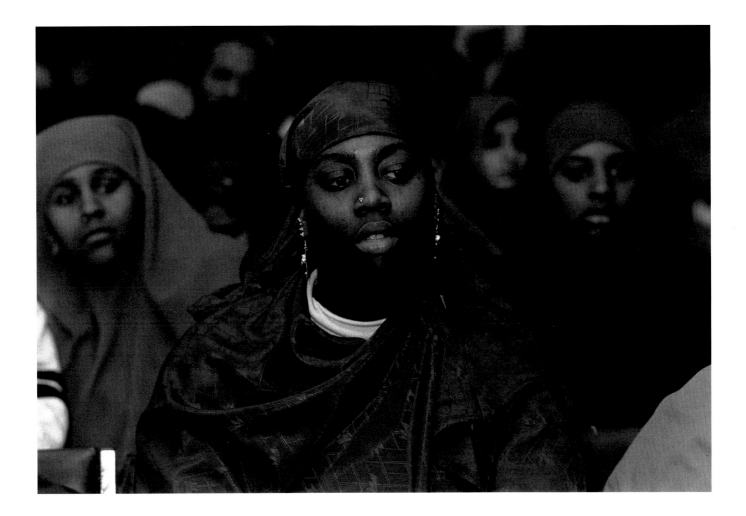

Haja Kali, Muslim Woman at Press Conference for the Masjid At-Taqwa,
Brooklyn, New York. February 1987.

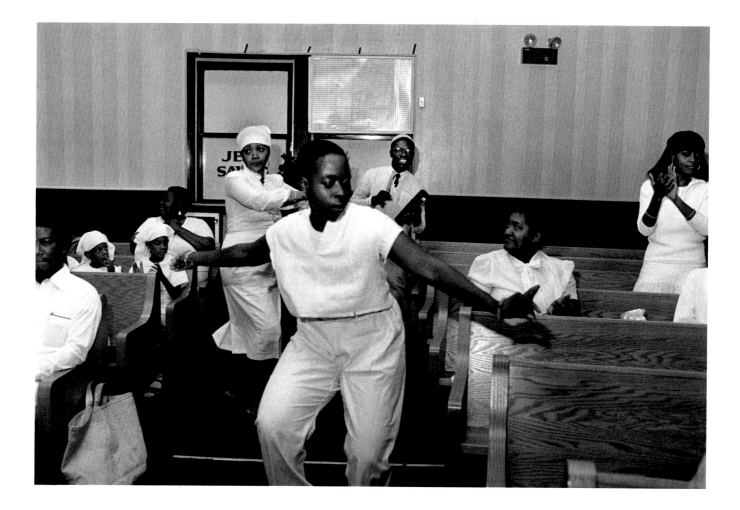

Dancing in Church, First Annual Community Baptism for the Afrikan Family,
Brooklyn, New York. June 1986.

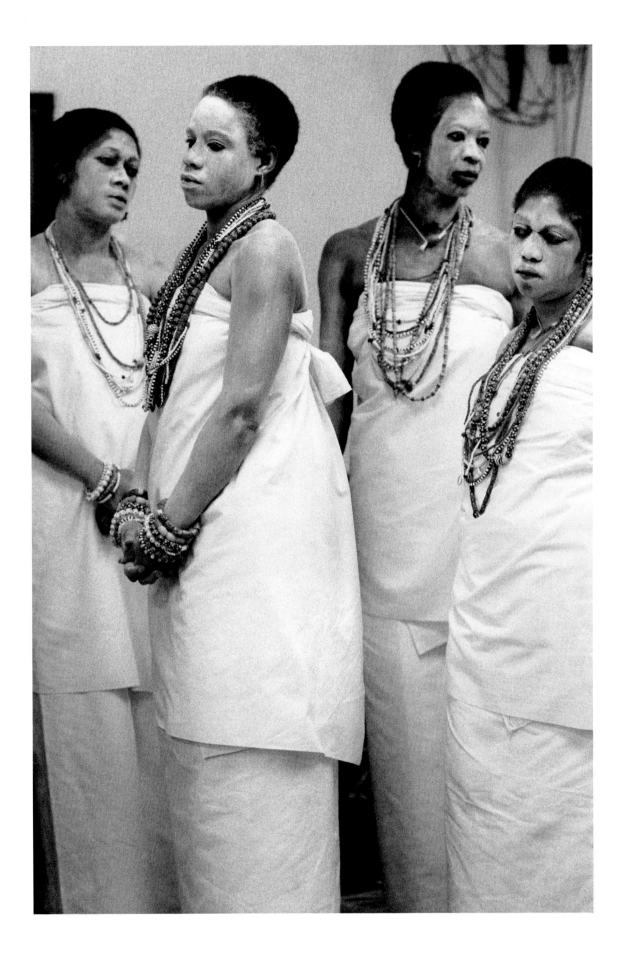

Akan Priestesses, Bosum Dzemawodzi Temple, Queens, New York. December 1983.

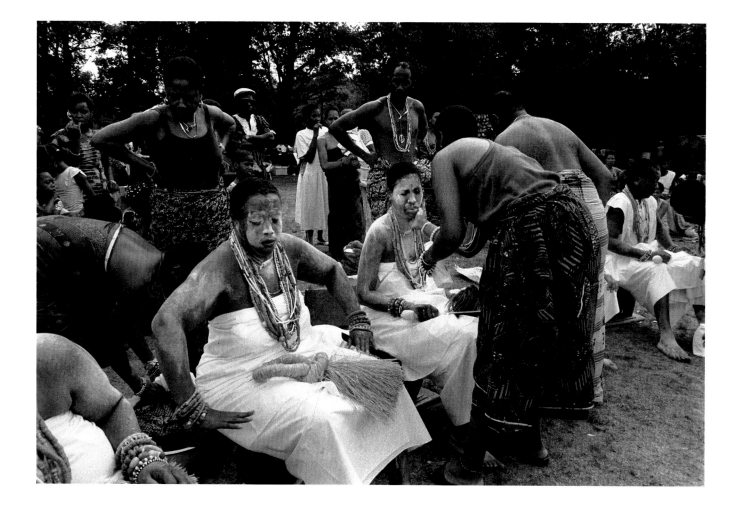

Akan Priest Graduation, Bosum Dzemawodzi Temple,
Queens, Cuddybackville, New York. July 1987.

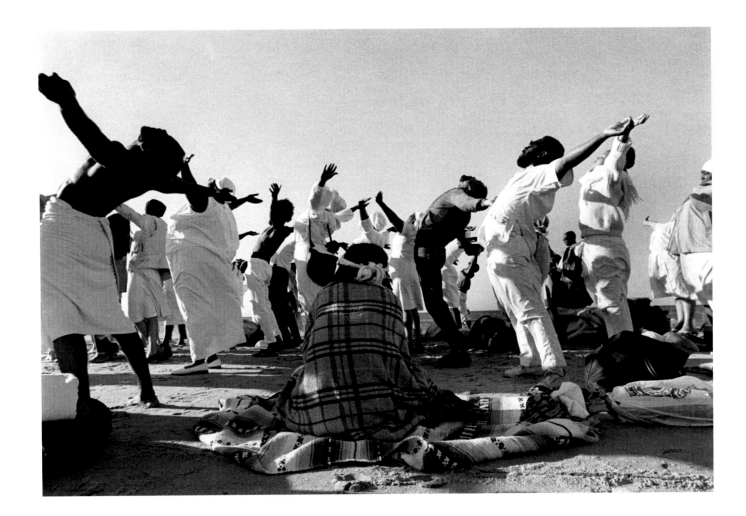

First Annual Community Baptism for the Afrikan Family,
Riis Beach, New York. June 1986.

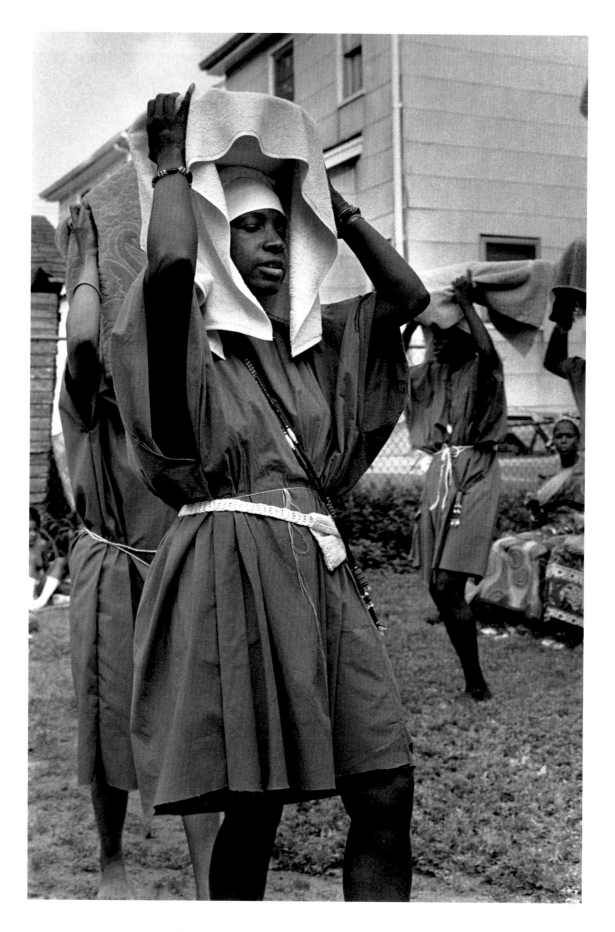

Dafua, Fodeima Endayo Sifuno (womens' initiation ceremony),
Queens, New York. June 1986.

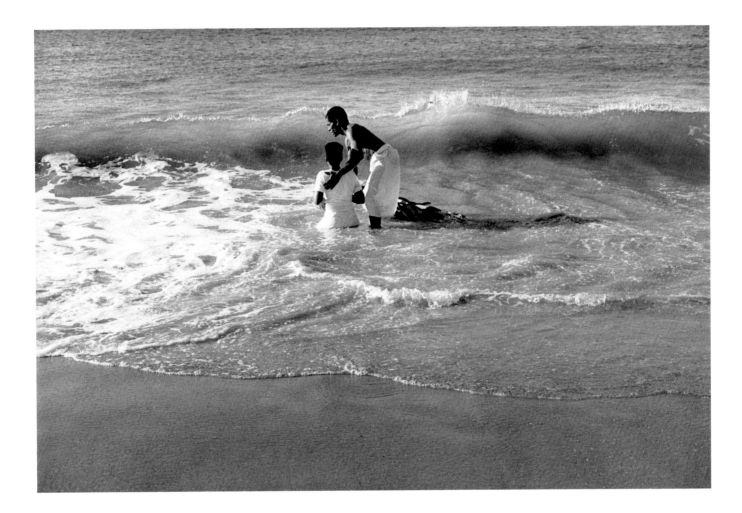

Baptism, First Annual Community Baptism for the Afrikan Family,

Riis Beach, New York. June 1986.

DOUG DUBOIS

Family Photographs

My mother's car came up the driveway more than ten minutes ago. She hadn't come in the house, so I imagined she'd be walking around the yard pulling weeds or picking vegetables from the garden. I picked up my camera and went outside. She stood at the end of the driveway next to her car. I thought of taking a picture, but then immediately wished I'd left my camera behind. I walked closer and stood with my mother. She wasn't hysterical, but her crying was from a depth I never allow myself to reach. I think I tried to say some things: "He'll be all right; it's just a matter of time." She turned from me, walked across the driveway and leaned on the basketball pole for support. Again, I saw my mother from a distance and this time took a picture. When I photograph I can be overwhelmed with anxiety. The camera marks me as an outsider; its presence denies my full participation. The act of photographing becomes a gesture of embarrassment: the camera hides my face. With my family, this anxiety has occurred so often that I feel I must be encouraging it. Perhaps I equate the tension with the intimacy I desire in my photographs. I take it as a sign that I am encountering difficult emotions, the ones I think produce the best pictures. In the spring of 1985, my father fell from a commuter train. On a late night express, he walked between two cars and was found six hours later lying between the east- and westbound tracks. It took him a year to recover and walk on his own again. The worst of this time was the summer, when his healing involved several operations and frustrating setbacks. I moved home to help out, but felt that life there was suspended. We were entirely focused on his recovery, and I photographed almost exclusively at the hospital, ignoring the rest of the family. When my father came home, he stayed on a hospital bed in the living room; I photographed the same drama with merely a change of scene. I moved to California in September. When I returned home for Christmas, I had not considered the distance, both in miles and experience, that now existed between us. I thought I could make up for what I ignored during the summer and photograph my family as I had idealized them—unchanged by the trauma of my father's accident. After dinner, we were silent. My parents sat on either side of me. We usually talked, but now they stared in opposite directions and I knew I was not in their thoughts. My father's daily care fell upon my mother, along with her responsibility for my brother, the house and the piles of medical bills. On New Year's Eve, my mother would suffer a nervous breakdown and be hospitalized for a month. I sat at the table and made a photograph, but I did not recognize my mother's illness. I remained outside her grief and saw only the space that separated my parents. The weeks that followed my mother's breakdown were times of profound isolation. Even though the family worked together in her absence, at night we remained separated in our rooms. I was restless and wandered from room to room with my camera. I never photographed, but thought that carrying it was a good excuse for my movements. My father slept in the sun room, and I always came in to say good night. We talked about my mother and how we could make things easier for her. We never discussed the guilt we shared over her breakdown. I assumed his feelings were more complex and deeper than mine, and that I had little to offer in return. In my most intimate photographs there is a detachment that speaks of my isolation. I no longer see my family as an assured source of comfort but as part of the confusion of my adult life. In the conflict between intimacy and detachment, I feel the loss of my childhood family. A year later, my parents danced on New Year's Eve. They were slow, romantic dances, but my father displayed a pride in each step. My mother was proud of her happiness and danced with her eyes closed. My brother and I were the audience. We applauded the songs and took pictures of the dancers. In the end we took turns dancing with my mother until the records finished and midnight arrived.

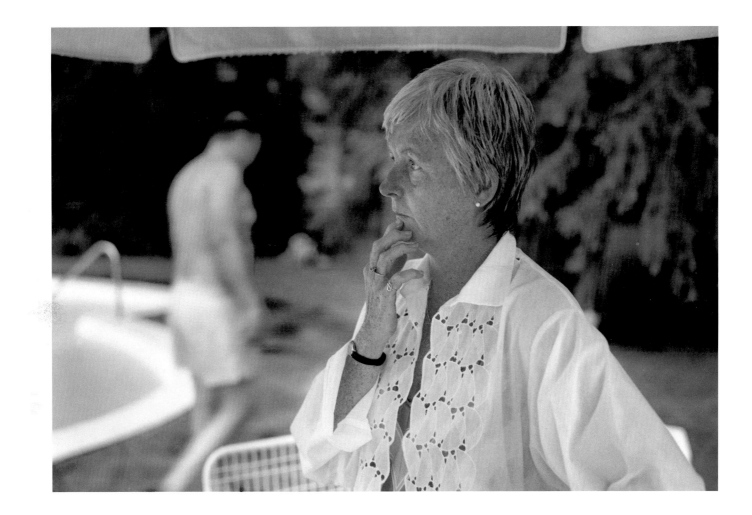

Summer, 1987

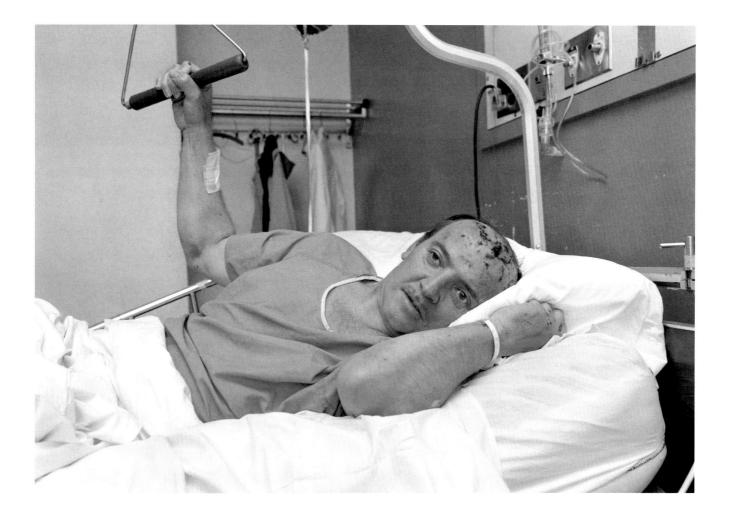

My Father, Hospital, May 1985

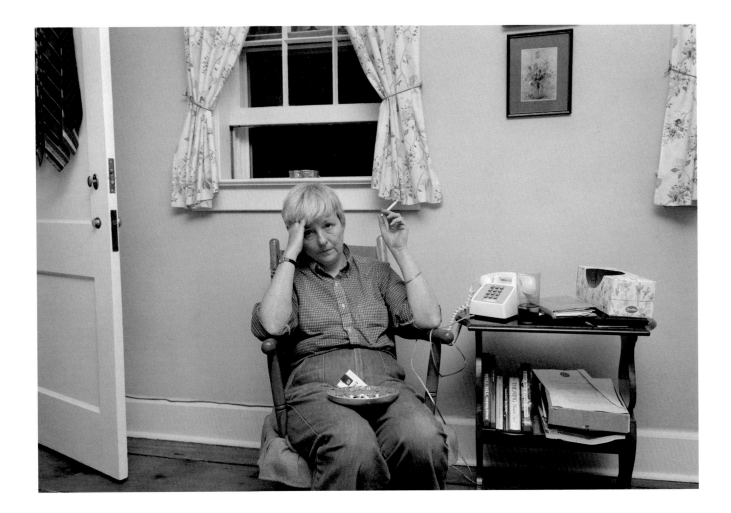

My Mother, May 1985

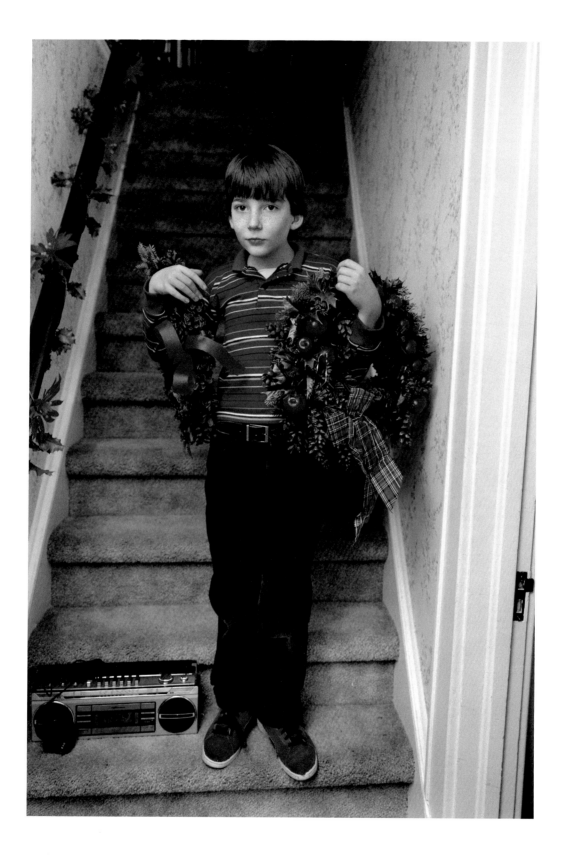

Luke, Christmas Eve, 1985

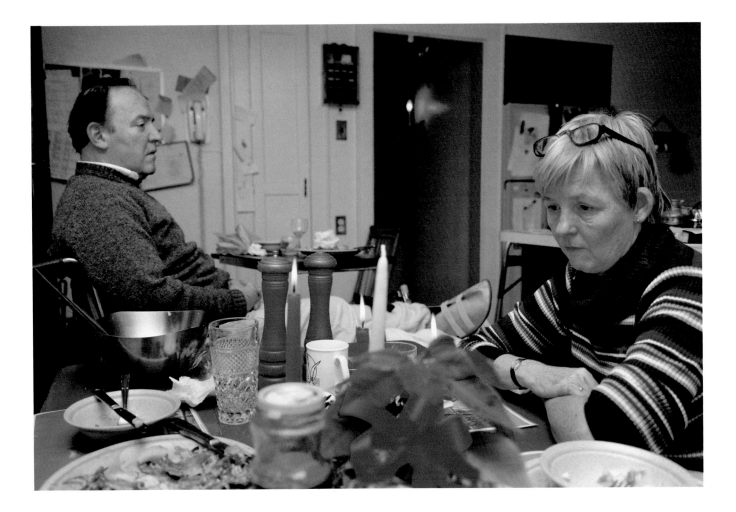

December, 1985

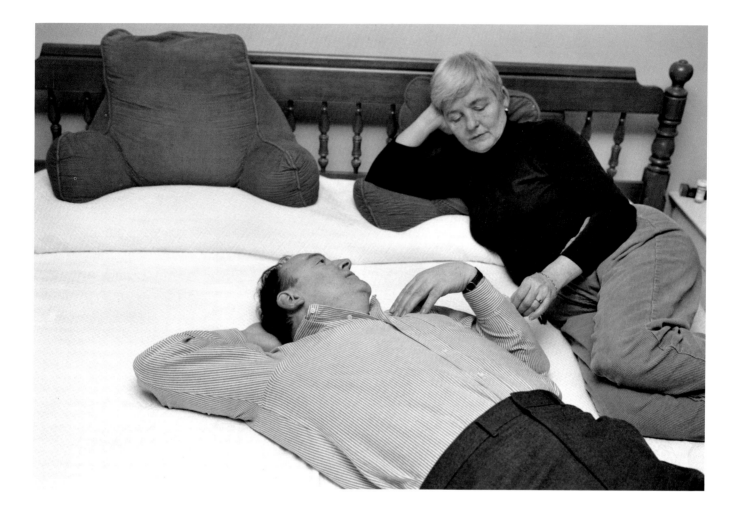

January, 1987

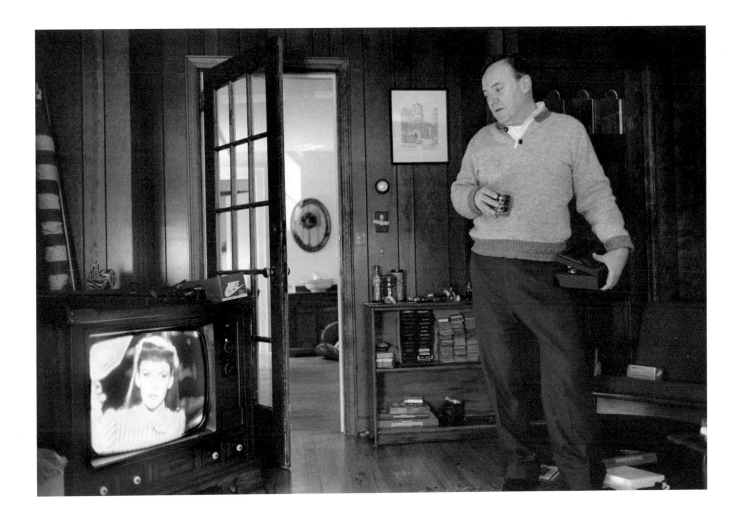

My Father, 1988

SHELBY LEE ADAMS

Kentucky Portraits

These photographs, made in the Appalachian Mountains of Eastern Kentucky, are part of a series begun in the summer of 1974. Today in Appalachia there are superhighways, fast-food restaurants, strip mines, discount stores, mobile homes and the usual plastic that decorates the rest of the country. These pictures are by no means typical of the area, however, and should not be interpreted as a general representation of Appalachian people or their culture today. Rather, this is a study of a people cut off from the mainstream; bypassed if you will by much of the developmental ephemera of Middle America. The subjects exist in isolated areas and experience what most Americans would consider impossible living conditions. Because I was born in the region and have relatives there, I know the backroads and paths to which most visitors are denied access. Every summer, when traveling through the mountains photographing, I am somehow able to renew and relive my childhood. I regain my southern, mountain accent and approach the people with openness, fascination and respect—they certainly treat me with respect. My psychic antenna becomes sharpened and acute. I love these people, perhaps that is it, plain and simple. I can respond to the sensual beauty of a hardened face with many scars, the deeply etched lines and flickers of sweat containing bright spots of sunlight. The eyes of my subjects reveal a kindness and curiosity, and their acceptance of me is rewarding. For me, this is a rejuvenation of the spirit of time past, and I am better for that experience each time it happens. My greatest fear as a photographer is to look into the eyes of a subject and not see my own reflection. These portraits are, in a way, self-portraits that represent a long autobiographical exploration of creativity, imagination, vision, repulsion and salvation. I hope my photographs confront viewers, reminding them of their own vulnerability and humanity. The selection of a person to be photographed is always a process of excitement and mystery. Why am I fascinated with some subjects more than others? Can it be that one person projects a more universal portrait than another? Do we as viewers identify with one person's physiognomy more that another's? To make a successful portrait requires an ability to penetrate beyond the superficial persona that most individuals present to the world. It is through photographing and knowing the subjects and identifying with their situations that something in myself is revealed. Each summer I return to Kentucky with two to three hundred $8'' \times 10''$ glossy photographs to give to my subjects. They usually introduce me to neighbors and friends whom I photograph, and the following summer I return with these pictures. Many times I photograph people as a favor to the family, expecting no great results, but these sessions often lead to new and interesting subjects. If the first attempt does not work with a particular individual, studying that image over time may lead to greater success the second or third time, even if the sessions are a full year apart. The *process* of making photographs is important to me, and the people I photograph share in that process from beginning to end. Using Polaroid prints is a convenient and helpful way of communicating my visual ideas with my subjects. Making a good portrait requires that the people photographed be involved and that they feel important. A successful image can only result from an intuitive interaction between the photographer and the subject.

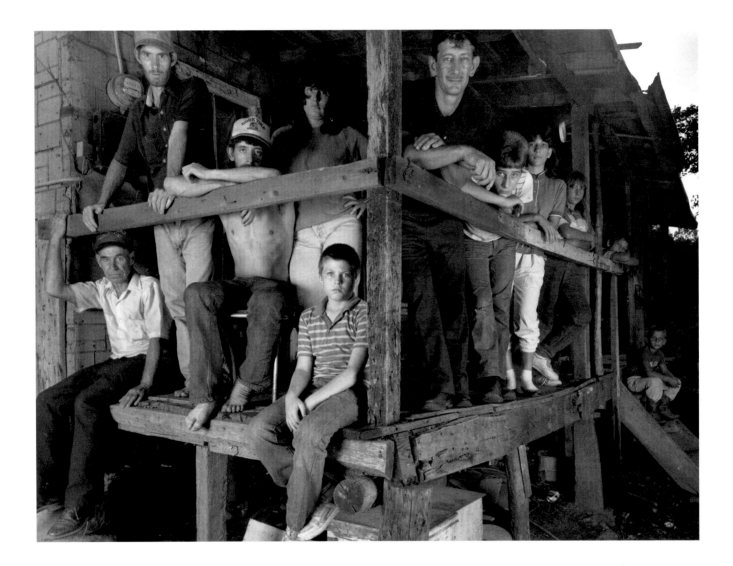

Banks Family Porch, Leatherwood, Kentucky, 1987

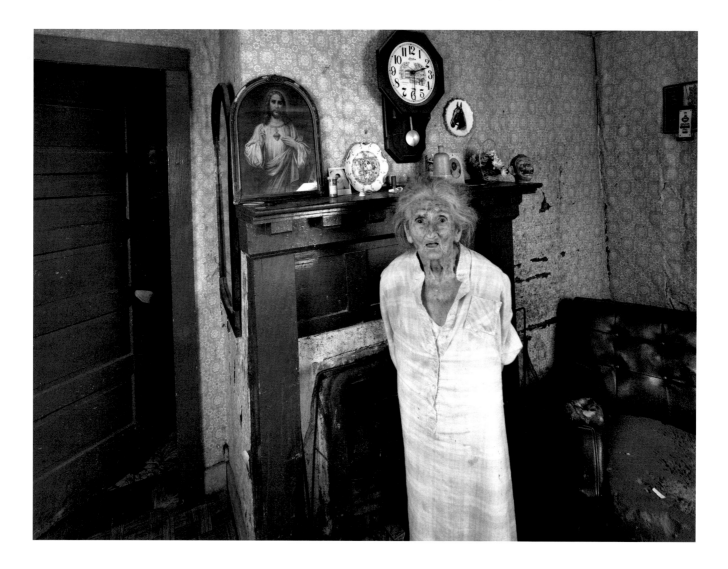

105 Year Old Woman, Rocky Hollow, Kentucky, 1986

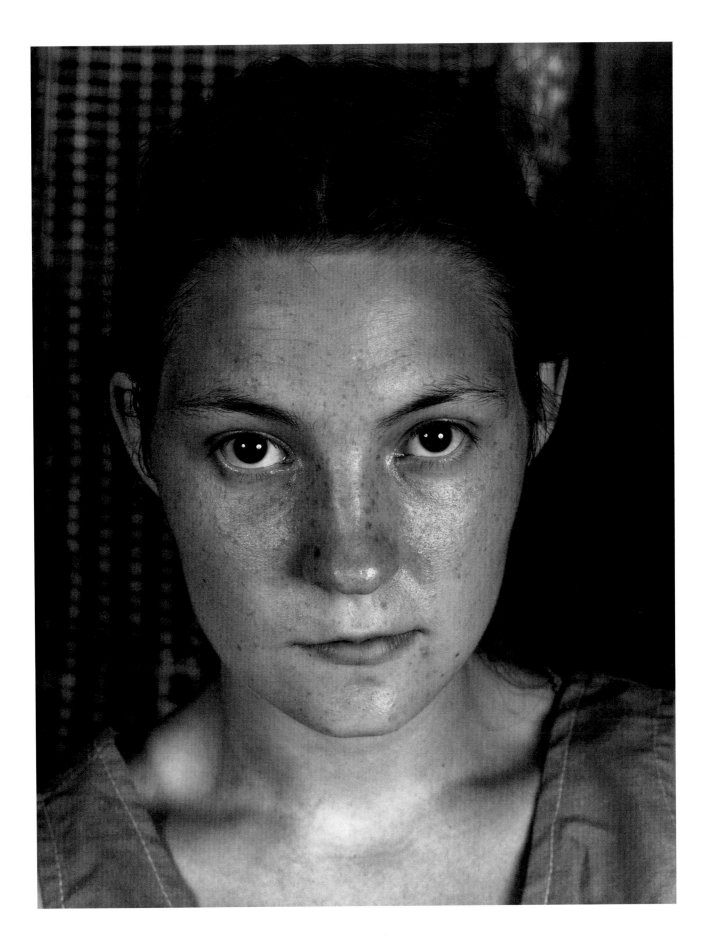

Rosa Lee, Neeley Branch, Kentucky, 1986

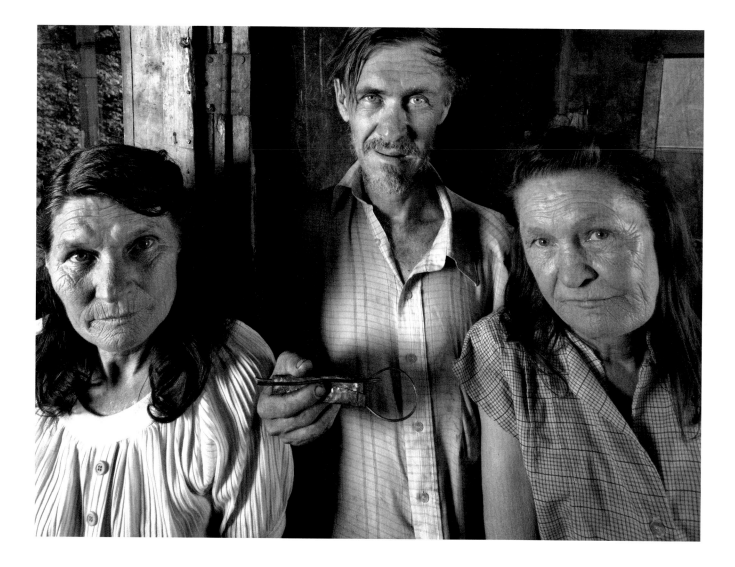

Leddie, Bert and Lonnie, Sloan Fork, Kentucky, 1988

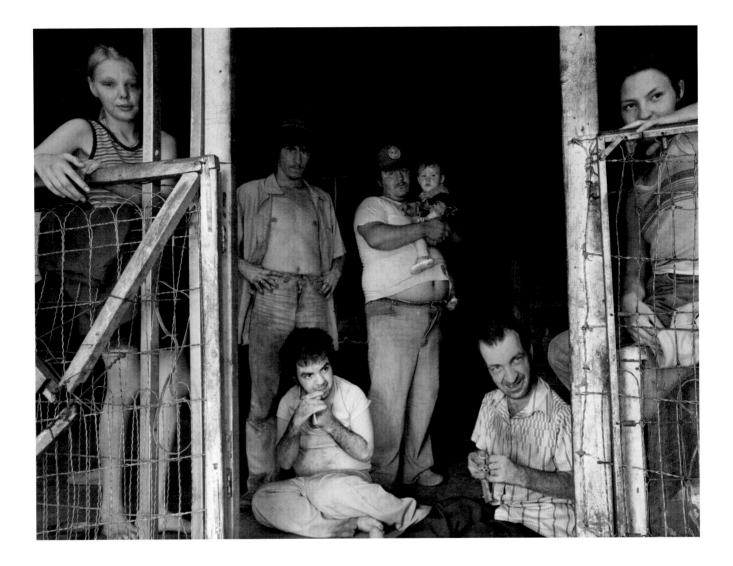

Childers Family Porch, Neeley Branch, Kentucky, 1986

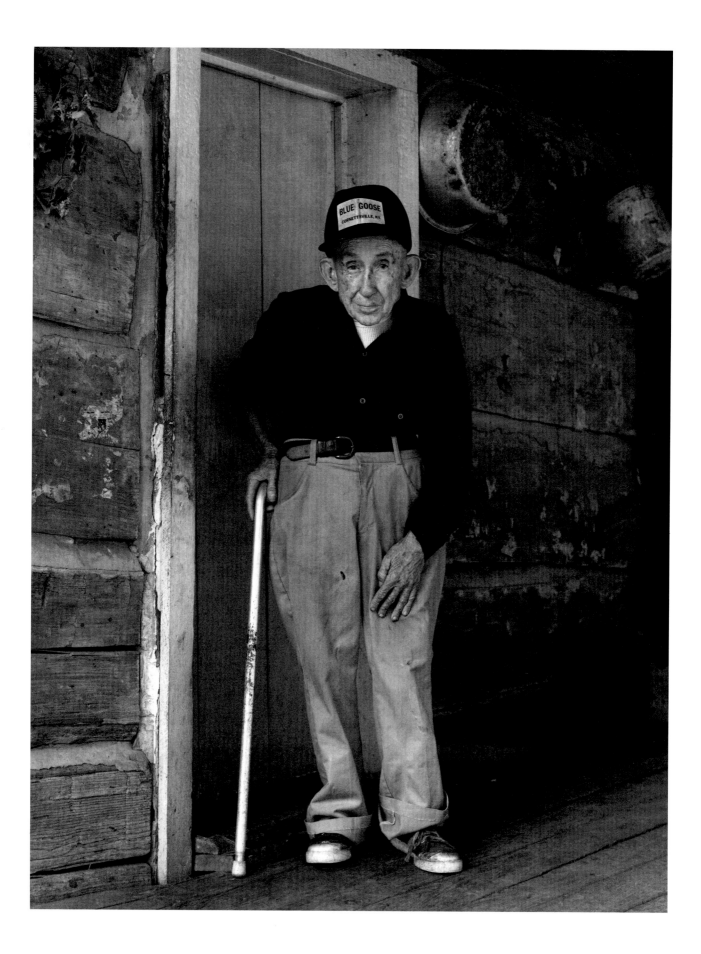

Mr. Dixon, Turkey Creek, Kentucky, 1985

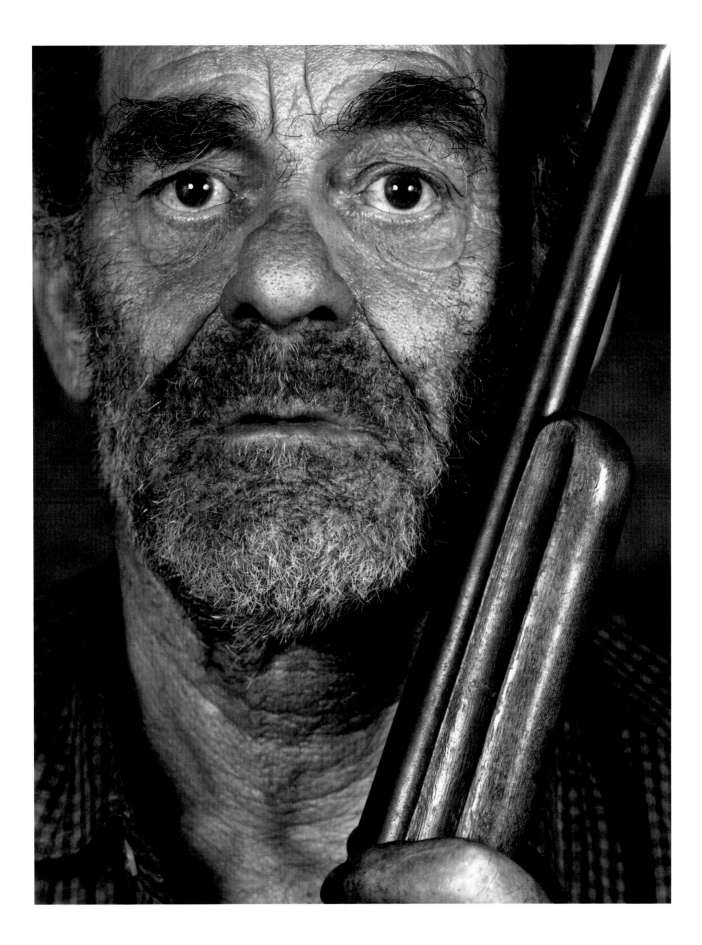

Jesse Estep, Harlan County, Kentucky, 1986